# Digital Health Care Initiatives

www.lulu.com
Lulu Press, Inc
627 Davis Drive, Suite 300,
Morrisville, NC 27560.

## Author Affiliations

**Dr. Tanvi Patel**,
Assistant Professor,
Department of Pharmacy Practice
Anand Pharmacy College,
Anand, Gujarat, India-388001.

**Mr. Maneshwar Thippani,**
Assistant Professor,
Department of Pharmaceutical Chemistry,
Anurag University,
Hyderabad, Telangana, India-500088.

**Dr. Mounika Nerella,**
Assistant Professor,
Department of Pharmaceutical Chemistry,
Anurag University,
Hyderabad, Telangana, India-500088.

**Dr. Shivani Patel,**
Assistant Professor,
Department of Pharmacy Practice,
Anand Pharmacy College,
Anand, Gujarat, India-388001.

First Printing: 2023
ISBN:
Copyright License @ Tanvi Patel, Maneshwar Thippani, Mounika Nerella, Shivani Patel.

This book has been published with all reasonable efforts to make the material error-free after the author's consent. No part of this book shall be used, or reproduced in any manner, without the author's permission, except for brief quotations embodied in critical articles and reviews.

The Author of this book is solely responsible and liable for its content, including but not limited to the views, representations, descriptions, statements, information, opinions, and references ["Content"]. The Content of this book shall not constitute or be construed or deemed to reflect the opinion or expression of the Publisher or Editor. Neither the Publisher nor Editor endorse or approve the Content of this book or guarantee the reliability, accuracy, or completeness of the Content published herein and do not make any representations or warranties of any kind, express or implied, including but not limited to the implied warranties of merchantability, fitness for a particular purpose. The Publisher and Editor shall not be liable whatsoever for any errors or omissions, whether such errors or omissions result from negligence, accident, or any other cause or claims for loss or damages of any kind, including without limitation, indirect or consequential loss or damage arising out of use, inability to use, or about the reliability, accuracy or sufficiency of the information contained in this book. This book was written based on Intelligence with the support of various sources.

# Digital Health Care Initiatives

By

Dr. Tanvi Patel

Mr. Maneshwar Thippani

Dr. Mounika Nerella

Dr. Shivani

2023

# About the Authors

**Dr. Tanvi Patel**, an Assistant Professor, participated and presented at various international and national conferences, webinars, workshops, symposiums, and tech fests. She was a member of the pharma hackathon of BITS Edu Campus. She was also certified in Basic Emergency Care and Medical Writing. She has expertise in treatment management, clinical pharmacokinetics, and day-to-day operations in pharmacy.

**Mr. Maneshwar Thippani** is working as an Assistant Professor in the Department of Pharmaceutical Chemistry with 12 years of teaching experience. He has actively participated in research activities for various UG and PG courses since his career started. He also attended and presented in multiple international and national conferences, symposiums, workshops, seminars, etc. He also published various international and national paper publications.

**Dr. Mounika Nerella** is working as an Assistant Professor in the Department of Pharmaceutical Pharmacology with 9 years of teaching experience. She has actively participated in research activities for various UG and PG courses since his career started. She also attended and presented in multiple international and national conferences, symposiums, workshops, seminars, etc. She also published various international and national paper publications.

**Dr. Shivani Patel**, an Assistant Professor, participated and presented at various international and national conferences, webinars, workshops, symposiums, and tech fests. She was also certified in Basic Emergency Care and Medical Writing. She has expertise in treatment management, clinical pharmacokinetics, and day-to-day operations in pharmacy.

# About Book

This book refers to gaining knowledge on technology and digital solutions to improve healthcare delivery, patient care, and overall health outcomes. These initiatives leverage mobile applications, wearables, telemedicine, artificial intelligence (AI), and data analytics to transform healthcare processes and enhance the patient experience.

# Table of Contents

Digital Health Care Initiatives ................................................................. 1
    Introduction ........................................................................................... 1
    Types of Digital Health Care Initiatives ............................................ 1
  A. Telemedicine ....................................................................................... 4
    Introduction ........................................................................................... 4
    Advantages and Key Features of Telemedicine ................................ 4
    Limitations of Telemedicine ................................................................ 5
  B. Electronic Health Records ................................................................. 8
    Introduction ........................................................................................... 8
    Advantages and Key Features of Electronic Health Records .......... 8
    Limitations of Electronic Health Records ....................................... 10
  C. Mobile Health (mHealth) Applications ........................................... 12
    Introduction ......................................................................................... 12
    Advantages and Key Features of mHealth Applications ................ 12
    Limitations of mHealth Applications ............................................... 14
  D. Artificial Intelligence in Healthcare ............................................... 16
    Introduction ......................................................................................... 16
    Advantages and Key Features of Artificial Intelligence in
    Healthcare ............................................................................................ 16
    Limitations of Artificial Intelligence in Healthcare ....................... 18
  E. Remote Patient Monitoring ............................................................. 21
    Introduction ......................................................................................... 21
    Advantages and Key Features of Remote Patient Monitoring ...... 21
    Limitations of Remote Patient Monitoring ..................................... 23
  F. Health Information Exchange .......................................................... 26

Introduction ................................................................................... 26

**Advantages and Key Features of Health Information Exchange** . 26

**Limitations of Health Information Exchange** ........................... 28

**G. Precision Medicine** ................................................................ 31

Introduction ................................................................................... 31

**Advantages and Key Features of Precision Medicine** ................ 31

**Limitations of Precision Medicine** ............................................. 33

**H(a). Data Analytics** ................................................................... 36

Introduction ................................................................................... 36

**Advantages and Key Features of Data Analytics** ....................... 36

**Limitations of Data Analytics** .................................................... 38

**H(b). Population Health Management** ..................................... 41

Introduction ................................................................................... 41

**Advantages and Key Features of population health management**
........................................................................................................... 41

**Limitations of Population Health Management** ....................... 43

**I(a). Virtual Reality** ..................................................................... 46

Introduction ................................................................................... 46

**Advantages and Key Features of Virtual Reality** ....................... 46

**Limitations of Virtual Reality** .................................................... 48

**I(b). Augmented Reality** ............................................................. 50

Introduction ................................................................................... 50

**Advantages and Key Features of Augmented Reality** ............... 50

**Limitations of Augmented Reality in Health Care** .................... 52

**J. Blockchain in Healthcare** ....................................................... 56

Introduction ................................................................................... 56

**Advantages and Key Features of Blockchain in Healthcare** .........56

**Limitations of Blockchain in Healthcare** ...........................................58

**Conclusion for Digital Healthcare Initiatives**.......................................61

Digital Health Care Initiatives

# Digital Health Care Initiatives

## Introduction

Digital healthcare initiatives refer to integrating technology and digital solutions into healthcare systems and processes to improve the delivery of healthcare services, enhance patient outcomes, and streamline administrative tasks. These initiatives leverage telemedicine, electronic health records (EHRs), mobile health applications, wearable devices, artificial intelligence (AI), and data analytics.

## Types of Digital Health Care Initiatives

Here are some notable digital healthcare initiatives:

A. *Telemedicine:* Telemedicine enables remote consultations between patients and healthcare providers through video calls or online platforms. It improves access to healthcare, especially for individuals in rural or underserved areas, and reduces the need for in-person visits for non-emergency cases.

B. *Electronic Health Records (EHRs):* EHRs digitize and centralize patient medical records, making them easily accessible to healthcare professionals. They facilitate the efficient sharing of patient information, reduce errors, and support continuity of care.

C. *Mobile Health (mHealth) Applications:* mHealth apps are designed for smartphones and wearable devices to monitor health conditions, track fitness goals, and deliver personalized healthcare information. They enable patients to actively participate in their care and provide real-time data to healthcare providers.

D. *Artificial Intelligence (AI) in Healthcare:* AI technologies, such as machine learning and natural language processing, are used to analyze

large volumes of medical data, detect patterns, and support clinical decision-making. AI can assist in diagnosing diseases, predicting patient outcomes, and optimizing treatment plans.

*E. Remote Patient Monitoring:* Remote patient monitoring devices, including wearable sensors, collect patient health data outside traditional healthcare settings. This data is transmitted to healthcare providers in real time, allowing early detection of health issues and remote management of chronic conditions.

*F. Health Information Exchange (HIE):* HIE systems enable secure sharing of patient health information among different healthcare organizations. They promote interoperability, reduce duplication of tests, and improve care coordination among providers.

*G. Precision Medicine:* Digital healthcare initiatives support the implementation of precision medicine approaches by utilizing genomic information, biomarkers, and advanced analytics to deliver targeted therapies and personalized treatment plans.

*H. Data Analytics and Population Health Management:* Advanced analytics and big data techniques help healthcare organizations analyze large datasets to identify trends, patterns, and health risks. This information supports proactive interventions, preventive care strategies, and resource allocation.

*I. Virtual Reality (VR) and Augmented Reality (AR):* VR and AR technologies are being explored for various healthcare applications, such as surgical training, pain management, and rehabilitation therapies. They offer immersive experiences and enhance patient engagement.

*J. Blockchain in Healthcare:* Blockchain technology is used to secure and manage health data, facilitate interoperability, and enable the secure sharing of patient records across healthcare providers. It enhances data privacy, reduces fraud, and improves data integrity.

These digital healthcare initiatives have the potential to transform healthcare delivery, improve patient outcomes, and enhance the overall efficiency of healthcare systems. However, addressing challenges such as data privacy, security, regulatory compliance, and equitable access is essential to ensure these initiatives successful implementation and adoption.

Digital Health Care Initiatives

# A. Telemedicine

## Introduction

Telemedicine is a healthcare practice that involves the remote delivery of medical services and consultations through telecommunications technology. It allows patients to interact with healthcare providers without being physically present in the exact location. Telemedicine utilizes various communication tools like video conferencing, phone calls, and secure messaging platforms to facilitate virtual appointments and remote medical care.

With telemedicine, patients can consult with healthcare professionals for various purposes, including routine check-ups, diagnosis of non-emergency conditions, follow-up appointments, medication management, and mental health counseling. It provides a convenient and accessible way for patients to receive medical care, particularly for individuals with limited mobility who live in rural or underserved areas or face other barriers to accessing healthcare.

## Advantages and Key Features of Telemedicine

*Increased Access:* Telemedicine breaks down geographical barriers and improves access to healthcare services, especially for individuals living in remote areas or areas with limited medical facilities. It enables patients to connect with healthcare providers who may be located far away.

*Convenience and Time Savings:* Telemedicine eliminates the need for patients to travel to medical facilities, saving time and reducing the associated costs and inconveniences. Virtual appointments can be scheduled at a time that suits both the patient and the healthcare provider, increasing flexibility.

*Continuity of Care:* Telemedicine allows patients to maintain regular contact with their healthcare providers, facilitating continuity of care. It benefits follow-up visits, chronic disease management, and medication monitoring.

*Cost Savings:* Telemedicine can be cost-effective for patients and healthcare providers. It reduces transportation, parking, and time away from work expenses. Additionally, it can help healthcare organizations optimize their resources and reduce healthcare costs.

*Remote Monitoring:* Telemedicine sometimes incorporates remote monitoring devices that collect and transmit patient data to healthcare providers. This enables monitoring vital signs, chronic conditions, and post-operative recovery from a distance.

Despite its advantages, telemedicine has some limitations. Not all medical conditions can be diagnosed or treated remotely, and certain situations may require in-person consultations. Additionally, technological barriers, such as limited internet access or lack of familiarity with digital platforms, can hinder the widespread adoption of telemedicine.

Overall, telemedicine has proven to be a valuable tool in expanding access to healthcare, improving patient convenience, and enhancing healthcare delivery, particularly in non-emergency situations.

## Limitations of Telemedicine

While telemedicine offers numerous benefits, it also has some limitations that must be considered. Here are some critical limitations of telemedicine:

*Limited Physical Examination:* Telemedicine relies on video conferencing or audio calls, restricting the healthcare provider's physical examination ability. Certain medical conditions may require

hands-on assessment, palpation, or specialized diagnostic equipment, making an in-person visit necessary.

*Technology Barriers:* Not all patients have access to reliable internet connections, smartphones, or computers, which are essential for participating in telemedicine consultations. This lack of technology or digital literacy can limit the reach of telemedicine, particularly among elderly populations or individuals in low-income areas.

*Inability to Handle Emergencies:* Telemedicine is primarily suitable for non-emergency medical issues. Telemedicine may not be sufficient in emergencies requiring immediate physical intervention or on-site medical equipment. Patients experiencing severe symptoms or injuries typically need to seek in-person emergency care.

*Diagnostic Limitations:* Some medical conditions may require diagnostic tests, such as X-rays, blood work, or biopsies, which cannot be performed remotely. Lack of access to physical diagnostic tools and procedures may hinder accurate diagnoses or delay necessary treatments.

*Limited Personal Connection:* In-person interactions between patients and healthcare providers often provide a sense of empathy, trust, and personal connection. Telemedicine consultations may offer a different level of interpersonal connection, potentially impacting the patient-provider relationship.

*Legal and Regulatory Considerations:* Telemedicine practices must adhere to specific legal and regulatory frameworks, which vary across regions and countries. Licensing requirements, privacy regulations, and reimbursement policies can create barriers to the widespread adoption of telemedicine.

*Patient Preferences and Comfort:* Some patients may prefer face-to-face consultations with healthcare providers for personal or cultural reasons. The absence of physical presence may impact patient

satisfaction or comfort levels, reducing engagement with telemedicine services.

*Limited Scope of Practice:* Certain healthcare specialties, such as surgical procedures or complex interventions, are challenging to perform remotely. Telemedicine is more applicable for consultations, follow-ups, and ongoing care management than complex procedures requiring physical presence.

*Data Security and Privacy Concerns:* Telemedicine involves transmitting sensitive patient information over digital platforms, raising concerns about data security and privacy breaches. Healthcare providers and technology platforms must ensure robust security measures and compliance with relevant regulations to protect patient information.

While telemedicine has limitations, it remains a valuable tool for expanding access to care, especially for non-emergency situations and routine healthcare needs. By understanding these limitations, healthcare providers can effectively determine when telemedicine is appropriate and in-person care is necessary.

# B. Electronic Health Records

## Introduction

Electronic Health Records (EHRs) are digital versions of patients' medical records containing comprehensive health information, including medical history, diagnoses, treatments, medications, allergies, laboratory test results, immunization records, and more. EHRs are designed to be accessible, shareable, and secure, allowing authorized healthcare providers to access and update the information as needed.

## Advantages and Key Features of Electronic Health Records

*Comprehensive Patient Information:* EHRs provide a centralized patient health information repository. They consolidate data from various sources, such as hospitals, clinics, laboratories, and pharmacies, into a single record. This comprehensive view of the patient's medical history helps healthcare providers make informed decisions and provide appropriate care.

*Accessibility and Interoperability:* EHRs can be accessed securely by authorized healthcare providers, allowing for seamless sharing of patient information across different healthcare settings. This interoperability enhances care coordination and continuity as providers can view up-to-date information, reducing the need for redundant tests or procedures.

*Improved Patient Safety:* EHRs can help prevent medical errors and adverse events. They provide decision support tools, such as drug interaction alerts and clinical guidelines, which help healthcare providers make safer and more accurate treatment decisions. EHRs also support electronic prescribing, reducing the risk of medication errors.

*Efficiency and Productivity:* Electronic records streamline administrative tasks, such as documentation, charting, and billing processes. They reduce reliance on paper-based systems, making searching, retrieving, and updating patient information easier. EHRs can also automate workflows, saving time for healthcare providers and staff.

*Data Analytics and Population Health Management:* EHRs generate large amounts of data that can be analyzed to identify trends, patterns, and population health risks. By leveraging data analytics, healthcare organizations can gain insights into disease prevalence, treatment outcomes, and population health trends, leading to better public health strategies and targeted interventions.

*Patient Engagement:* EHRs can empower patients to participate actively in their care. Many EHR systems include patient portals that allow patients to access their health information, request appointments, communicate with their healthcare providers, view test results, and manage their healthcare preferences.

*Data Privacy and Security:* EHRs incorporate security measures to protect patient data, such as encryption, access controls, and audit logs. They comply with privacy regulations, like the Health Insurance Portability and Accountability Act (HIPAA) in the United States, to ensure patient privacy and confidentiality.

It is important to note that adopting and implementing EHRs require careful planning, training, and consideration of data privacy and security concerns. Healthcare organizations must ensure the proper training of staff, adherence to best practices, and robust data protection measures to maximize the benefits of EHRs while safeguarding patient information.

## Limitations of Electronic Health Records

While Electronic Health Records (EHRs) offer numerous advantages, they also have several limitations to address. Here are some critical limitations of EHRs:

*Interoperability Challenges:* EHR systems from different healthcare organizations often have varying formats, data standards, and technical capabilities. This lack of interoperability can hinder the seamless sharing and exchange of patient information between different systems, leading to fragmented records and difficulties in care coordination.

*Data Entry and Usability Issues:* EHR systems often require healthcare providers to spend significant time and effort on data entry and documentation tasks. The usability of some EHR interfaces may need to be more intuitive and user-friendly, leading to potential workflow disruptions and provider frustration.

*Potential for Information Overload:* EHRs can generate large volumes of data, including redundant or irrelevant information. This abundance of data can overwhelm healthcare providers, making it challenging to quickly identify and access critical information.

*Data Privacy and Security Concerns:* EHRs contain sensitive patient information, and the electronic nature of these records raises concerns about data privacy and security. Safeguarding EHRs against unauthorized access, data breaches, and cyber threats requires robust security measures and adherence to privacy regulations.

*Reliance on Technology:* EHR systems heavily depend on technology infrastructure, including hardware, software, and network connectivity. Technical issues, such as system failures or outages, can disrupt access to patient information and impact patient care.

*Training and Learning Curve:* Healthcare providers and staff require proper training to effectively and efficiently use EHR systems. The learning curve associated with adopting new technologies and workflows can initially slow down productivity and increase resistance to change.

*Potential for Information Errors:* Data entry errors, such as typos or the selection of incorrect options, can occur when entering information into EHR systems. These errors can have significant implications for patient care if not identified and corrected promptly.

*Cost and Implementation Challenges:* Implementing EHR systems can be a costly endeavor for healthcare organizations, involving expenses related to hardware, software licenses, training, and ongoing maintenance. Smaller healthcare providers or resource-constrained settings may need help implementing and sustaining EHR systems.

*Limited Standardization:* While there are standards in place for certain aspects of EHRs, such as data exchange formats (e.g., HL7), there still needs to be complete standardization across all components of EHR systems. This lack of standardization can impede data interoperability and hinder the seamless exchange of information.

Efforts are being made to address these limitations and improve the functionality and usability of EHR systems. Initiatives such as the development of standardized data exchange formats, improved user interfaces, and interoperability standards aim to overcome these challenges and enhance the benefits of EHRs for healthcare providers and patients.

## C. Mobile Health (mHealth) Applications

### Introduction

Mobile Health (mHealth) applications are mobile device applications, typically smartphones or tablets, designed to provide healthcare-related services and information. These applications leverage the capabilities of mobile devices, such as wireless connectivity, GPS, sensors, and touchscreens, to support various aspects of healthcare, wellness management, and medical information delivery. mHealth apps are typically available for download from app stores and can cover various functionalities and purposes.

### Advantages and Key Features of mHealth Applications

*Health Tracking and Monitoring:* Many mHealth apps enable users to track and monitor their health conditions, fitness activities, and vital signs. They may include step counters, heart rate monitors, sleep trackers, and calorie counters. Some apps can connect to wearable devices or sensors to gather real-time data.

*Medication Management:* mHealth apps can assist users in managing their medications by providing reminders for medication schedules, tracking medication intake, and sending alerts for prescription refills. They can help improve medication adherence and reduce the risk of missed doses.

*Telemedicine and Virtual Consultations:* Some mHealth apps provide platforms for virtual consultations, connecting patients with healthcare providers through video calls or secure messaging.

This enables remote medical consultations and access to healthcare advice without the need for in-person visits.

*Health Education and Information:* Many mHealth apps offer educational resources and information on various health topics. They may provide access to articles, videos, interactive tools, and personalized health recommendations to empower users to make informed decisions about their health and well-being.

*Symptom Checkers and Diagnosis Support:* Certain mHealth apps provide symptom checkers and diagnostic support tools. Users can input their symptoms, and the app may provide potential causes or guidance on when to seek medical attention. However, it is essential to note that these tools are not a substitute for professional medical advice or diagnosis.

*Wellness and Lifestyle Management:* mHealth apps can support users in managing their overall wellness and lifestyle goals. They may include features for nutrition tracking, exercise planning, stress reduction techniques, meditation guides, and smoking cessation support.

*Chronic Disease Management:* Some mHealth apps are designed to help individuals manage chronic conditions such as diabetes, hypertension, asthma, or mental health disorders. These apps can provide tools for self-monitoring, symptom management, treatment reminders, and connection to support communities.

*Emergency Assistance and First Aid:* Certain mHealth apps offer guidance and instructions for basic first aid procedures, emergency preparedness, and access to emergency services. They can provide immediate assistance during critical situations.

It is important to note that while mHealth apps can be beneficial tools, they should not replace professional medical advice or treatment. Users should exercise caution in selecting apps, ensuring they come from reputable sources and adhere to appropriate privacy and security standards.

mHealth applications can empower individuals to take control of their health, improve healthcare access, enhance self-management, and facilitate communication between patients and healthcare providers.

## Limitations of mHealth Applications

While mobile health (mHealth) applications offer various advantages, they also have limitations that must be considered. Here are some critical limitations of mHealth applications:

*Limited Accessibility:* mHealth apps rely on mobile devices and internet connectivity. Not all individuals have access to smartphones or reliable internet connections, particularly in resource-limited or rural areas. This can create disparities in access to mHealth services, potentially excluding specific populations from benefiting fully.

*Reliability and Accuracy:* The reliability and accuracy of mHealth apps can vary significantly. Not all apps undergo rigorous scientific validation or regulatory oversight. Some apps may provide inaccurate information or unreliable functionality, potentially leading to incorrect self-diagnosis or ineffective treatment decisions.

*User Engagement and Adoption:* While mHealth apps offer various features, user engagement and sustained adoption can be challenging. Many apps need higher user retention rates or a lack of long-term motivation. Complex user interfaces, limited usability, or lack of personalized content may reduce user engagement.

*Data Privacy and Security Risks:* mHealth apps collect and store sensitive user health data. The privacy and security measures these apps implement may vary, potentially raising concerns about unauthorized access or data breaches. App developers must prioritize robust data protection measures and comply with privacy regulations.

*Lack of Standardization and Integration:* The mHealth app landscape is highly diverse, requiring more standardization regarding

functionality, data formats, and interoperability. This lack of standardization can hinder data exchange between apps or healthcare systems, potentially limiting their effectiveness in care coordination and integration.

*Regulatory and Quality Control Challenges:* The rapid growth of mHealth apps has outpaced the development of regulatory frameworks and quality control processes. App stores may need to thoroughly evaluate all listed apps' accuracy, safety, or effectiveness. This can make it challenging for users to identify trustworthy and evidence-based apps.

*Ethical Considerations:* mHealth apps may raise ethical concerns about data ownership, informed consent, and potential biases in algorithms or health recommendations. App developers must be transparent about data usage and ensure ethical practices to protect user rights and trust.

*Integration with Healthcare Systems:* While mHealth apps have the potential to enhance healthcare delivery, their integration with existing healthcare systems can be complex. Data sharing, interoperability, reimbursement, and liability challenges may arise when integrating mHealth apps into traditional healthcare workflows.

*User Proficiency and Health Literacy:* Effective mHealth app utilization relies on users' digital and health literacy skills. Some individuals, particularly older adults, or those with limited technological familiarity, may face challenges in navigating and fully utilizing the functionalities of mHealth apps.

It is crucial for users to carefully evaluate mHealth apps, considering factors such as user reviews, app credibility, data privacy policies, and professional recommendations. Healthcare providers can guide patients toward reliable and validated mHealth apps aligning with their healthcare needs.

## D. Artificial Intelligence in Healthcare

Introduction

Artificial Intelligence (AI) in healthcare refers to applying AI technologies and techniques to improve healthcare delivery, diagnostics, treatment, research, and overall patient outcomes. AI systems in healthcare leverage algorithms, machine learning, deep learning, natural language processing, and other AI methodologies to analyze and interpret vast amounts of data, make predictions, assist in decision-making, and automate specific tasks.

### Advantages and Key Features of Artificial Intelligence in Healthcare

*Medical Imaging and Diagnostics:* AI algorithms can analyze medical images such as X-rays, CT scans, and MRIs to detect abnormalities, diagnose diseases, and provide quantitative measurements. AI has shown promising results in detecting conditions like cancers, cardiovascular diseases, and retinal diseases, improving accuracy and efficiency in image interpretation.

*Electronic Health Records (EHR) and Clinical Documentation:* AI can help extract relevant information from unstructured clinical notes, radiology reports, and other medical documents. Natural language processing techniques enable the conversion of free-text data into structured formats, making it easier for healthcare providers to access and analyze patient information.

*Predictive Analytics and Risk Assessment:* AI can analyze patient data, including medical records, genetic information, and lifestyle factors, to predict the risk of developing certain diseases or conditions. This can aid in early intervention, preventive care, and personalized treatment planning.

*Drug Discovery and Development:* AI analyzes vast amounts of biomedical data and scientific literature to identify potential drug targets, predict drug efficacy and toxicity, and accelerate drug discovery and development. AI algorithms can assist in the virtual screening of compounds, drug repurposing, and optimizing clinical trial design.

*Virtual Assistants and Chatbots:* AI-powered virtual assistants and chatbots can provide basic medical information, answer common health questions, and offer triage support. They can help users assess symptoms, provide self-care advice, and direct individuals to appropriate healthcare resources or services.

*Remote Monitoring and Wearable Devices:* AI can analyze data from wearable devices, such as fitness trackers or smartwatches, to monitor patients' health parameters, track activity levels, and detect irregularities. This enables remote patient monitoring, early detection of health issues, and timely interventions.

*Robot-assisted Surgery:* AI technologies are integrated into surgical robots to assist surgeons in performing complex procedures with enhanced precision and accuracy. AI can provide real-time feedback, assist decision-making during surgery, and improve outcomes in minimally invasive and robotic-assisted surgery.

*Precision Medicine and Treatment Planning:* AI can analyze genetic data, biomarkers, and patient characteristics to personalize treatment plans and optimize medication choices. It can help identify patient subgroups that may respond differently to treatments and support precision medicine approaches.

*Health Data Analytics and Population Health Management:* AI algorithms can analyze large-scale health data, including electronic health records, medical claims, and public health data, to identify

patterns, trends, and population health risks. This aids in disease surveillance, public health planning, and resource allocation.

It is important to note that while AI has the potential to revolutionize healthcare, it should always be used as a tool in conjunction with clinical expertise. Ethical considerations, data privacy, transparency, and regulatory compliance are crucial in developing and deploying AI technologies in healthcare to ensure patient safety and trust.

## Limitations of Artificial Intelligence in Healthcare

While Artificial Intelligence (AI) holds significant promise in healthcare, several limitations and challenges must be considered. Here are some critical limitations of AI in healthcare:

*Data Quality and Bias:* AI algorithms heavily rely on high-quality and diverse datasets for training. In healthcare, the availability of comprehensive and unbiased datasets can be a challenge. Partial or incomplete data may lead to biased AI predictions or inaccurate outcomes, especially if the training data must adequately represent diverse populations.

*Interpretability and Explain ability:* Some AI models, such as deep learning neural networks, can be complex and challenging to interpret or explain. This lack of transparency in AI decision-making can make it difficult for healthcare providers to understand and trust AI-generated recommendations. Explainable AI techniques are being developed to address this limitation.

*Limited Generalizability:* AI models trained on specific datasets or contexts may have limited generalizability to different patient populations or healthcare settings. The performance of AI algorithms may vary when applied to new data or different clinical environments, requiring careful validation and adaptation.

*Regulatory and Legal Considerations:* The regulatory frameworks for AI in healthcare are still evolving. Ensuring compliance with privacy regulations, ethical guidelines, and liability concerns related to AI-generated decisions can be challenging. Legal and regulatory considerations must be addressed to establish accountability and ensure patient safety.

*Human-AI Collaboration:* The effective integration of AI into healthcare workflows and decision-making processes requires careful consideration of human-AI collaboration. The role of healthcare providers and their involvement in AI-generated recommendations or decisions must be defined to maintain patient trust and ensure the responsible use of AI.

*Ethical Challenges:* AI in healthcare raises ethical considerations, such as privacy, consent, data ownership, and algorithmic fairness. Safeguarding patient privacy, ensuring informed consent, and addressing biases in AI algorithms are critical to maintaining ethical standards and protecting patient rights.

*Cost and Resource Intensiveness:* Implementing AI technologies in healthcare can be resource-intensive and costly. Training AI models, acquiring and maintaining the necessary infrastructure, and integrating AI into existing healthcare systems may require significant investments. This can pose challenges, especially for smaller healthcare organizations or resource-limited settings.

*Adoption and Acceptance:* Widespread adoption and acceptance of AI in healthcare can be hindered by resistance to change, lack of awareness, and scepticism among healthcare providers or patients. Adequate training, education, and demonstration of the value and benefits of AI are necessary to foster acceptance and encourage adoption.

Addressing these limitations requires a multidisciplinary approach involving healthcare professionals, AI experts, regulators, policymakers, and patients. Continued research, transparency, collaboration, and adherence to ethical guidelines will be crucial in maximizing the benefits and minimizing the risks associated with AI in healthcare.

# E. Remote Patient Monitoring

## Introduction

Remote Patient Monitoring (RPM) is a healthcare practice involving technology monitoring patients' health remotely outside traditional healthcare settings. It allows healthcare providers to track patients' vital signs, symptoms, and health-related data in real time from a distance. RPM aims to enhance patient care, improve outcomes, and enable timely interventions by providing continuous monitoring and proactive management of patient's health conditions.

## Advantages and Key Features of Remote Patient Monitoring

*Monitoring Devices:* RPM utilizes various medical devices and sensors to collect patient data. These devices can include wearable devices like heart rate monitors, blood pressure cuffs, glucose meters, pulse oximeters, smartwatches, and home-based monitoring devices like weight scales or spirometers. These devices capture and transmit patient-generated data to healthcare providers or monitoring centers.

*Data Transmission and Connectivity:* RPM relies on secure and reliable communication channels to transmit patient data from the monitoring devices to healthcare providers or designated monitoring centers. This can be achieved through internet connectivity, wireless networks, or dedicated communication systems.

*Data Analysis and Interpretation:* The collected patient data is analyzed and interpreted using algorithms and AI techniques to detect abnormalities, patterns, or trends that may indicate changes in a patient's health status. Healthcare providers can review and interpret the data to make informed decisions about patient care.

Digital Health Care Initiatives

*Remote Alerts and Notifications:* RPM systems can generate alerts or notifications to healthcare providers when certain predefined thresholds or criteria are met. These alerts can help identify urgent or critical situations that require immediate attention or intervention.

*Patient Engagement and Education:* RPM encourages active patient participation in health management. Patients are educated about their health conditions, the proper use of monitoring devices, and the importance of self-monitoring. RPM systems may also provide educational resources, reminders, or prompts to encourage healthy behaviors and self-care.

*Care Coordination and Communication:* RPM facilitates communication and collaboration between patients and healthcare providers. Healthcare teams can remotely review patient data, conduct virtual consultations, provide feedback, and adjust treatment plans. This enables ongoing care coordination and reduces the need for frequent in-person visits.

*Chronic Disease Management:* RPM is particularly valuable in managing chronic diseases. It enables continuous monitoring of vital signs, medication adherence, symptom tracking, and early detection of complications. RPM can empower patients to actively participate in managing their chronic conditions and improve their overall quality of life.

*Post-Acute Care and Transition Management:* RPM can support patients during the post-acute care phase, such as after hospital discharge or surgery recovery. Remote monitoring allows healthcare providers to monitor patients' progress closely, detect potential complications, and intervene promptly.

RPM offers several benefits, including improved access to care, reduced hospital readmissions, early detection of health deteriorations, personalized care plans, and increased patient

satisfaction. It has proven particularly useful for individuals with chronic conditions, older adults, and those in remote or underserved areas. However, RPM faces challenges related to data security, regulatory compliance, patient adherence, and reimbursement models, which must be addressed for widespread adoption and effective implementation.

## Limitations of Remote Patient Monitoring

While Remote Patient Monitoring (RPM) offers numerous advantages, limitations, and challenges are associated with its implementation. Here are some critical limitations of RPM:

*Technology and Infrastructure Requirements:* RPM relies on appropriate technology and infrastructure availability, including reliable internet connectivity and compatible monitoring devices. In areas with limited access to technology or inadequate infrastructure, implementing RPM may be challenging, leading to disparities in healthcare access.

*Patient Adherence and Engagement:* The success of RPM depends on patient adherence to self-monitoring protocols and active engagement in their care. Some patients may need help using monitoring devices, consistently transmitting data, or following monitoring schedules. Low patient adherence can compromise the effectiveness of RPM and limit its impact on patient outcomes.

*Data Overload and Interpretation:* RPM generates large volumes of patient data, including vital signs, symptoms, and other health-related information. Healthcare providers may need help managing and interpreting this influx of data. Developing practical algorithms and tools to filter, analyze, and present meaningful insights from the data is crucial to ensure its clinical utility.

*Privacy and Data Security:* RPM involves collecting, transmitting, and storing sensitive patient health data. Ensuring privacy and data security is paramount to protect patient confidentiality and comply with relevant regulations. Robust security measures must be implemented to safeguard patient information from unauthorized access or breaches.

*Reimbursement and Financial Sustainability:* RPM services' reimbursement models and financial considerations are still evolving. Establishing sustainable reimbursement frameworks that adequately compensate healthcare providers for the additional time and resources required for RPM implementation can be challenging. Clear reimbursement policies may help widespread adoption.

*Integration with Healthcare Systems:* Integrating RPM data into existing healthcare systems, such as electronic health records (EHRs), can be complex. Ensuring seamless data exchange, interoperability, and integration with healthcare workflows is necessary for effective communication and care coordination between RPM systems and healthcare providers.

*Diagnostic Limitations:* RPM is valuable for monitoring patients' health status but may only sometimes provide a comprehensive diagnostic assessment. Remote monitoring focuses on collecting physiological data and patient-reported information, which may have limitations in diagnosing complex medical conditions or evaluating subjective symptoms.

*Regulatory and Legal Considerations:* RPM is subject to regulatory requirements and legal considerations. Compliance with privacy regulations, informed consent, data ownership, and liability issues must be addressed. Staying abreast of evolving regulations and ensuring adherence to ethical guidelines is essential to protect patient rights and maintain legal compliance.

*Equity and Access:* Despite the potential benefits of RPM, disparities in access to technology, digital literacy, and healthcare resources can hinder its widespread adoption and impact. Ensuring equitable access to RPM for all patient populations, regardless of socioeconomic status, geographic location, or technological proficiency, is a critical consideration.

Overcoming these limitations requires addressing technological, organizational, regulatory, and financial challenges. Collaboration among healthcare providers, policymakers, technology developers, and patients is crucial to ensure RPM initiatives' effective implementation and long-term success.

# F. Health Information Exchange

## Introduction

Health Information Exchange (HIE) is the electronic sharing and exchanging of health-related information between healthcare organizations, systems, and stakeholders. It enables the secure and interoperable exchange of patient health records, clinical data, test results, medications, and other relevant health information among authorized healthcare providers and entities involved in a patient's care.

## Advantages and Key Features of Health Information Exchange

*Electronic Data Exchange:* HIE facilitates electronic health information exchange in a standardized and structured format. It enables healthcare providers to securely share patient data across different healthcare settings, including medical records, laboratory results, radiology reports, medication history, and care plans.

*Interoperability:* HIE aims to achieve interoperability, which refers to the ability of different healthcare systems and technologies to communicate and exchange data seamlessly. It ensures authorized users can access, understand, and use health information effectively, regardless of the specific systems or applications.

*Continuity of Care:* HIE promotes continuity of care by enabling healthcare providers to access comprehensive and up-to-date patient information, regardless of the healthcare setting. This helps to ensure that healthcare decisions are informed, coordinated, and based on the most current and relevant patient data.

*Patient-Centered Care:* HIE supports patient-centered care by providing healthcare providers with a complete picture of a patient's

health history and treatment. It allows for better care coordination, reduced duplication of tests or procedures, and improved patient safety through accurate and timely information exchange.

*Care Transitions and Referrals:* HIE facilitates the seamless transfer of patient information during care transitions, such as when a patient is referred from one healthcare provider to another or transitioning between different care settings (e.g., hospital to primary care). It helps to ensure that critical patient information is available to the receiving provider, enabling informed decision-making and smoother transitions.

*Public Health Surveillance:* HIE can contribute to public health surveillance efforts by enabling the timely reporting and sharing of notifiable conditions, infectious disease data, and other population health information. It aids in early detection and response to public health threats and supports monitoring and reporting on health trends at a population level.

*Emergency Situations and Disaster Response:* HIE plays a crucial role in emergencies and disaster response. In such situations, quickly accessing and sharing patient information across different healthcare organizations and jurisdictions can be critical for providing timely and appropriate care to affected individuals.

*Data Privacy and Security:* HIE systems prioritize the privacy and security of patient information. Robust security measures, such as encryption, access controls, audit trails, and data integrity checks, are implemented to protect health data from unauthorized access or breaches. Compliance with relevant privacy regulations, such as HIPAA in the United States, is essential.

HIE requires the participation and collaboration of various stakeholders, including healthcare providers, hospitals, clinics, laboratories, pharmacies, public health agencies, and health

information organizations. Standards, protocols, and governance frameworks are established to ensure secure and standardized data exchange practices. HIE aims to enhance care coordination, improve patient outcomes, and support data-driven decision-making across the healthcare ecosystem.

## Limitations of Health Information Exchange

While Health Information Exchange (HIE) offers numerous benefits, limitations, and challenges are associated with its implementation. Here are some critical limitations of HIE:

*Interoperability Challenges:* Achieving seamless interoperability between healthcare systems and technologies can be complex. Variations in data formats, coding systems, and terminologies used across different systems can hinder the effective exchange and interpretation of health information. Ensuring consistent standards and robust data mapping mechanisms is necessary to overcome interoperability challenges.

*Fragmented Data:* Healthcare data is often stored in disparate systems across multiple healthcare organizations. HIE may need help accessing and integrating data from various sources, leading to incomplete or fragmented patient records. Overcoming data fragmentation requires comprehensive data aggregation and integration strategies to ensure a complete and accurate view of a patient's health history.

*Data Governance and Privacy Concerns:* HIE involves the sharing and exchanging of sensitive patient health information. Ensuring patient privacy, data security, and compliance with privacy regulations, such as HIPAA in the United States, is paramount. Establishing robust data governance frameworks, consent management mechanisms, and secure data-sharing protocols is essential to address privacy concerns and maintain patient trust.

*Variability in Data Quality:* HIE relies on the quality of the data being exchanged. Only accurate, complete, and consistent data can ensure the effectiveness and reliability of HIE. Variability in data quality across different healthcare organizations and systems may require data cleansing, validation, and standardization processes to ensure the accuracy and reliability of exchanged information.

*Cost and Resource Intensiveness:* Implementing and maintaining HIE infrastructure and connectivity can be resource-intensive and costly. Healthcare organizations must invest in technology, interfaces, security measures, and ongoing support to establish and sustain HIE capabilities. Smaller healthcare organizations or those with limited resources may need help adopting and maintaining HIE solutions.

*Workflow Integration and User Adoption:* Integrating HIE into healthcare workflows and routines can be challenging. Healthcare providers and staff may need to adapt their workflows to accommodate HIE processes, which can disrupt established practices and require training and change management efforts. Ensuring user adoption and acceptance of HIE among healthcare professionals is crucial for its successful implementation.

*Legal and Policy Frameworks:* HIE operates within a complex legal and policy landscape. Different jurisdictions may have varying regulations, consent requirements, and data-sharing policies that impact HIE operations. Harmonizing legal and policy frameworks, addressing cross-border data-sharing challenges, and ensuring compliance with relevant regulations are necessary for effective HIE implementation.

*Trust and Security Concerns:* Healthcare organizations and patients need to trust the security and confidentiality of HIE systems. Concerns about data breaches, unauthorized access, or misuse of patient information can impact trust and hinder the adoption of HIE. Strong security measures, regular audits, and transparent

communication about data protection practices are essential to address trust and security concerns.

Addressing these limitations requires collaboration among healthcare organizations, technology vendors, policymakers, and regulatory bodies. Standardizing data formats, promoting data quality initiatives, enhancing privacy and security measures, and developing comprehensive governance frameworks are essential steps toward maximizing the benefits of HIE while addressing its limitations.

# G. Precision Medicine

## Introduction

Precision medicine, also known as personalized medicine, is an approach to healthcare that considers individual variability in genes, environment, and lifestyle when diagnosing and treating diseases. It recognizes that each person is unique and aims to tailor medical decisions and interventions to the specific characteristics of each patient.

## Advantages and Key Features of Precision Medicine

*Genomics and Molecular Profiling:* Precision medicine incorporates advanced technologies, such as DNA sequencing and molecular profiling, to analyze an individual's genetic makeup and identify specific genetic variations or alterations associated with disease risk, progression, or response to treatment. This information can help guide personalized treatment decisions.

*Personalized Risk Assessment:* Precision medicine uses genetic and environmental information to assess an individual's risk of developing certain diseases. By understanding an individual's genetic predispositions and environmental factors, healthcare providers can offer targeted preventive strategies and screening recommendations.

*Targeted Therapies:* Precision medicine enables targeted therapies designed to act on molecular targets or genetic abnormalities identified in an individual's disease. This approach aims to improve treatment outcomes by focusing on therapies more likely to be effective for a particular patient.

*Pharmacogenomics:* Pharmacogenomics is a crucial component of precision medicine, focusing on how an individual's genetic makeup affects their medication response. By considering a patient's genetic

profile, healthcare providers can identify optimal drug choices, dosages, and potential adverse reactions, leading to more effective and personalized treatment plans.

*Data Integration and Artificial Intelligence:* Precision medicine leverages the integration of various data sources, including genomic data, electronic health records, lifestyle information, and clinical data, to generate comprehensive patient profiles. Advanced analytics, machine learning, and artificial intelligence techniques are applied to these integrated datasets to identify patterns, predict disease outcomes, and guide treatment decisions.

*Patient Empowerment and Participation:* Precision medicine emphasizes the importance of patient engagement and shared decision-making. Patients are actively involved in understanding their genetic and health information, participating in treatment decisions, and making informed choices about their healthcare.

Precision medicine can improve patient outcomes, enhance treatment effectiveness, reduce adverse reactions, and optimize resource allocation in healthcare. By tailoring medical interventions to individual patients, precision medicine aims to deliver more personalized, targeted, and efficient care. It is precious in managing complex diseases like cancer, cardiovascular disorders, and rare genetic conditions.

However, challenges associated with the widespread implementation of precision medicine include the cost and accessibility of genetic testing, the interpretation and integration of complex genomic data, the need for specialized expertise, and the ethical and privacy considerations related to genetic information. Overcoming these challenges requires ongoing research, technological advancements, collaboration among various stakeholders, and the development of robust regulatory and ethical frameworks.

## Limitations of Precision Medicine

While precision medicine holds great promise, several limitations and challenges must be addressed for its widespread implementation. Here are some critical limitations of precision medicine:

*Limited Data Availability:* Precision medicine heavily relies on large-scale genomic and clinical data to identify meaningful patterns and associations. However, the availability of comprehensive and diverse datasets can be limited, particularly for rare diseases or underrepresented populations. More data may help the ability to draw accurate conclusions or develop precise treatment strategies.

*Complex Data Interpretation:* Interpreting and analyzing genomic data is complex. There are numerous genetic variations, and their significance concerning disease risk, progression, or treatment response may only sometimes be well understood. The interpretation of genomic data requires ongoing research, robust bioinformatics tools, and well-curated databases to translate genetic information into actionable insights accurately.

*Ethical and Privacy Concerns:* Precision medicine involves collecting and analyzing sensitive genetic and health information. Safeguarding patient privacy and maintaining data security is critical to maintaining patient trust. Ensuring that data is anonymized, obtaining informed consent, and protecting against unauthorized access or misuse are essential considerations in the ethical implementation of precision medicine.

*Limited Treatment Options:* While precision medicine aims to provide targeted therapies based on individual characteristics, the availability of such treatments may be limited. Not all diseases have well-established targeted therapies, and developing new treatments tailored to specific genetic alterations can be challenging and time-consuming.

Sometimes, targeted therapies may be prohibitively expensive or inaccessible to specific patient populations.

*Cost and Accessibility:* Implementing precision medicine can be costly in terms of genetic testing and the development of targeted therapies. The cost of sequencing, analyzing genomic data, and the affordability of targeted treatments may present barriers to widespread adoption. Ensuring affordability and accessibility for all patient populations is essential to address healthcare disparities.

*Limited Understanding of Gene-Environment Interactions:* Precision medicine considers genetic factors and environmental and lifestyle influences on disease. However, understanding gene-environment interactions is still evolving, and accurately integrating this information into treatment decisions can be challenging. Comprehensive and longitudinal data on environmental exposures and their impact on health outcomes are necessary to improve the precision of treatment strategies.

*Integration with Healthcare Systems:* Integrating precision medicine into existing healthcare systems and workflows can be complex. Incorporating genomic information into electronic health records (EHRs), developing decision support tools, and ensuring effective communication and collaboration among healthcare professionals require substantial coordination and infrastructure adjustments.

*Education and Awareness:* Precision medicine involves complex scientific concepts and technologies that healthcare providers and the public may need to understand more widely. Adequate education and awareness initiatives ensure that healthcare professionals, patients, and the broader public understand precision medicine, its benefits, and its limitations.

Addressing these limitations requires ongoing research, technological advancements, collaboration among various

stakeholders, and developing policies and frameworks that promote equitable access, privacy protection, and ethical considerations. Continued investment in research and infrastructure, along with improved data sharing and collaboration, will be essential to overcome these challenges and fully realize the potential of precision medicine.

# H(a). Data Analytics

## Introduction

Data analytics in healthcare refers to collecting, organizing, analyzing, and interpreting vast amounts of healthcare data to extract meaningful insights and drive informed decision-making. It involves applying statistical analysis, predictive modeling, machine learning, and other analytical techniques to healthcare data sets, including electronic health records (EHRs), claims data, medical images, genomics data, and patient-generated data.

Data analytics in healthcare aims to improve patient outcomes, enhance operational efficiency, optimize resource allocation, and drive evidence-based decision-making across various areas of healthcare.

## Advantages and Key Features of Data Analytics

*Clinical Decision Support:* Data analytics assists healthcare providers in making informed decisions by analyzing patient data, medical literature, and clinical guidelines. It helps identify patterns, predict disease progression, suggest treatment options, and alert clinicians to potential adverse events or drug interactions. Clinical decision support systems powered by data analytics can improve diagnostic accuracy, enhance patient safety, and support evidence-based care.

*Population Health Management:* Data analytics supports population health management efforts by analyzing population-level data to identify health risks, stratify patients based on risk levels, and target interventions. It helps healthcare organizations identify high-risk populations, predict disease trends, develop preventive strategies, and optimize resource allocation for improved health outcomes.

*Health Outcomes and Quality Improvement:* Data analytics enables healthcare organizations to measure and evaluate health outcomes and the quality of care. By analyzing patient outcomes, readmission rates, mortality rates, complications, and adherence to best practices, organizations can identify areas for improvement, implement interventions, and track progress over time. This helps drive quality improvement initiatives and enhances patient safety and satisfaction.

*Healthcare Operations and Resource Optimization:* Data analytics helps improve operational efficiency and resource allocation in healthcare organizations. By analyzing patient flow, bed utilization, staffing patterns, supply chain management, and financial data, organizations can identify bottlenecks, streamline processes, reduce waste, and optimize resource allocation to improve efficiency and reduce costs.

*Research and Clinical Trials:* Data analytics is crucial in health research and clinical trials. Researchers can analyze large-scale datasets to identify trends, patterns, and associations, aiding in discovering new treatments, drug development, and advancements in medical knowledge. Data analytics helps in patient recruitment for clinical trials, monitoring trial progress, and evaluating outcomes to ensure the safety and efficacy of new treatments.

*Fraud Detection and Risk Management:* Data analytics helps identify fraudulent activities, billing irregularities, and potential risks in healthcare systems. By analyzing claims data, provider patterns, and billing records, organizations can detect fraudulent activities and identify areas where fraud and abuse are more likely to occur. Data analytics helps identify potential risks, predict adverse events, and implement risk mitigation strategies.

Data analytics in healthcare requires robust data governance, privacy protection, and data security measures to ensure the ethical and secure use of sensitive patient information. It relies on

interoperable data systems, advanced analytics tools, and skilled data scientists to derive meaningful insights and drive positive healthcare outcomes.

## Limitations of Data Analytics

While data analytics offers tremendous potential in healthcare, several limitations and challenges must be considered. Here are some critical limitations of data analytics:

*Data Quality and Availability:* The quality and availability of healthcare data can vary significantly. Only complete, accurate, and consistent data can affect the accuracy and reliability of data analytics results. Data may be fragmented across different systems, making integration and analysis complex. Inconsistent coding practices and documentation standards can also pose challenges to data quality.

*Data Privacy and Security:* Healthcare data contains sensitive and personally identifiable information, making privacy and security critical concerns. Ensuring compliance with data protection regulations, maintaining data privacy, and safeguarding against unauthorized access or breaches is essential. Striking a balance between data utilization for analytics and protecting patient privacy can be challenging.

*Data Interoperability:* Integrating data from different sources and systems with varying formats and standards can be challenging. Lack of interoperability between systems can hinder data aggregation and sharing, limiting the ability to analyze data comprehensively and gain a holistic view of patient's health.

*Interpretation and Bias:* Data analytics relies on the interpretation of data, and there is a risk of misinterpretation or biased analysis. Human bias, such as selection or confirmation bias, can influence the analysis and lead to incorrect conclusions or recommendations. It is essential

to have skilled data analysts and domain experts to ensure accurate interpretation and mitigate biases.

*Complexity and Technical Expertise:* Data analytics requires specialized technical skills, including statistical analysis, programming, and machine learning. Organizations need trained data analysts and data scientists who understand healthcare domain knowledge and have expertise in applying appropriate analytics techniques. The need for more skilled professionals in this field can be a limitation.

*Resource Requirements:* Implementing data analytics infrastructure and tools, such as data storage, computational resources, and analytics software, can be costly. Small healthcare organizations or those with limited resources may need help investing in the necessary infrastructure and maintaining ongoing support.

*Legal and Ethical Considerations:* Using data analytics in healthcare raises legal and ethical considerations. Ensuring compliance with privacy regulations, obtaining appropriate consent, and protecting against potential misuse or unintended consequences are essential considerations. The ethical implications of using patient data for analytics, such as data ownership and transparency, must be addressed.

*Generalizability of Results:* Data analytics results are based on the available data, which may not represent the entire population. Findings from data analytics may need to be more generalizable to diverse populations or healthcare settings. Extrapolating insights from one population to another without considering contextual factors can lead to ineffective or biased recommendations.

Addressing these limitations requires a comprehensive approach that includes data governance practices, data quality improvement initiatives, investment in interoperable systems, ongoing

training of personnel, and adherence to legal and ethical standards. Collaboration between stakeholders, including healthcare providers, researchers, policymakers, and technology vendors, is crucial to address these challenges and maximize the benefits of data analytics in healthcare.

# H(b). Population Health Management

## Introduction

Population health management (PHM) refers to the strategic and systematic approach to improving the health outcomes of a specific population or community. It focuses on addressing the health needs and risks of a defined group of individuals rather than focusing solely on individual patients. PHM encompasses a range of interventions, programs, and policies aimed at improving the overall health and well-being of the population.

## Advantages and Key Features of population health management

Assessing Health Needs and Risks: PHM begins with a comprehensive assessment of the target population's health needs, risks, and characteristics. This involves analyzing demographic data, health behaviors, social determinants of health, and health outcomes to understand the population's health status better.

*Risk Stratification:* After assessing the population's health risks, PHM involves stratifying individuals based on their level of risk for certain health conditions or poor health outcomes. This helps identify high-risk individuals who may benefit from targeted interventions and resources.

*Care Coordination and Management:* PHM emphasizes care coordination and management to ensure individuals receive appropriate and timely healthcare services. It involves implementing strategies to improve care transitions, enhance care coordination between different healthcare providers and settings, and optimize the use of healthcare resources.

*Prevention and Health Promotion:* PHM focuses on preventive measures and health promotion activities to address the underlying determinants of health and prevent the onset of diseases. This includes promoting healthy lifestyles, providing preventive screenings and vaccinations, and implementing community-wide interventions to improve population health.

*Data Analytics and Insights:* PHM relies on data analytics to gather insights and inform decision-making. By analyzing population-level data, such as electronic health records, claims data, and social determinants of health, healthcare organizations can identify trends, patterns, and areas for improvement. Data analytics helps in risk stratification, identifying care gaps, and evaluating the effectiveness of interventions.

*Patient Engagement:* Engaging and empowering individuals within the target population is a crucial aspect of PHM. It involves promoting patient education, shared decision-making, and self-management practices to actively involve individuals in their care and promote better health outcomes.

*Collaboration and Partnerships:* Effective population health management requires collaboration among healthcare providers, public health agencies, community organizations, and other stakeholders. Collaborative partnerships help leverage resources, share best practices, and implement comprehensive approaches to address population health needs.

Population health management aims to improve health outcomes, enhance the patient experience, and control healthcare costs by addressing health disparities, promoting preventive care, and optimizing the use of resources. PHM aims to improve the overall health and well-being of populations and communities by taking a proactive and holistic approach.

## Limitations of Population Health Management

While population health management (PHM) offers significant potential for improving health outcomes, several limitations and challenges must be considered. Here are some critical limitations of PHM:

*Data Availability and Quality:* PHM relies on the availability and quality of data to assess population health needs, identify risk factors, and monitor outcomes. However, data may need to be completed, fragmented, or of varying quality, hindering accurate analysis and decision-making. Inadequate data collection systems, inconsistent coding practices, and data privacy concerns can limit the effectiveness of PHM initiatives.

*Limited Resources:* Implementing comprehensive PHM programs requires adequate financial, human, and technological resources. Smaller healthcare organizations or those with limited funding may need help developing and sustaining PHM initiatives. Resource constraints can impact the scalability and reach of interventions, limiting their impact on population health.

*Fragmented Healthcare Systems:* Healthcare systems are often fragmented, with multiple providers, organizations, and stakeholders involved in delivering care. Coordinating care, sharing information, and aligning efforts across these diverse entities can be challenging. Fragmentation can hinder seamless care transitions, care coordination, and collaboration, impacting the effectiveness of PHM efforts.

*Limited Community Engagement:* Successful PHM requires active community engagement and involvement. However, engaging and mobilizing communities can be challenging due to diverse cultural, socioeconomic, and linguistic factors. Building trust, addressing health disparities, and incorporating community perspectives into

PHM initiatives are essential but resource-intensive and time-consuming.

*Complex Health Determinants:* Population health is influenced by many factors beyond the healthcare system, including social determinants of health (e.g., socioeconomic status, education, housing, and environment). Addressing these complex determinants requires collaboration across public health, education, housing, and policy-making sectors. The multifaceted nature of these determinants can pose challenges in implementing effective interventions and measuring their impact.

*Changing Population Dynamics:* Populations are dynamic and constantly evolving. Changes in population demographics, disease patterns, and healthcare needs require ongoing adaptation and adjustment of PHM strategies. Keeping up with these changes and ensuring the relevance and effectiveness of interventions can be demanding.

*Long-term Impact Evaluation:* Assessing the long-term impact of PHM interventions can be challenging. Evaluating the effectiveness of population-level interventions, measuring outcomes, and attributing changes to specific interventions are complex tasks. The influence of external factors and the time lag between interventions and observable outcomes can make it difficult to establish causality and accurately measure the impact of PHM initiatives.

*Health Inequities:* PHM aims to improve health outcomes for all individuals within a population. However, inequities in access to care, social determinants of health, and healthcare disparities can create challenges in achieving equitable health outcomes. Addressing health inequities requires targeted strategies, policy changes, and collaboration with stakeholders beyond the healthcare sector.

Addressing these limitations requires a comprehensive and multifaceted approach, including data infrastructure improvements, resource allocation, intersectoral collaboration, community engagement, and ongoing evaluation of interventions. PHM initiatives should be adaptable, contextually relevant, and responsive to the evolving needs of populations to maximize their impact on improving population health.

# I(a). Virtual Reality

## Introduction

Virtual Reality (VR) in healthcare refers to using immersive virtual reality technology to provide medical treatments, therapies, training, education, and patient experiences in a virtual environment. It involves the creation of computer-generated simulations that can replicate real-world scenarios or create entirely new environments for various healthcare applications.

Virtual reality technology typically involves a head-mounted display (HMD) or other wearable devices that immerse the user in a simulated environment. Users can interact with the virtual environment through controllers, motion sensors, or haptic feedback systems. This technology creates a sense of presence and immersion, allowing users to feel physically in the virtual world.

## Advantages and Key Features of Virtual Reality

*Medical Training and Education:* Virtual reality provides a realistic and interactive medical training and education platform. It enables healthcare professionals to practice complex procedures, surgical simulations, and patient interactions in a controlled and safe virtual environment. VR-based training can enhance skills, improve surgical outcomes, and reduce risks associated with real-world training.

*Pain Management and Distraction:* Virtual reality has been used as a non-pharmacological intervention for pain management. By immersing patients in a virtual environment, VR can distract them from painful procedures, such as wound dressings or injections. The immersive experience and engaging content can help reduce anxiety, stress, and perceived pain levels.

*Rehabilitation and Physical Therapy:* Virtual reality is utilized in rehabilitation and physical therapy to enhance motor function, balance, and coordination. Patients can engage in interactive exercises and simulations stimulating specific movements and actions. VR-based rehabilitation programs provide real-time feedback, motivation, and customized therapy plans, improving patient engagement and outcomes.

*Mental Health and Therapy:* Virtual reality has shown promise in treating mental health conditions, such as anxiety disorders, phobias, and post-traumatic stress disorder (PTSD). It allows therapists to gradually create controlled, personalized environments to expose patients to anxiety-provoking situations. VR therapy can help patients confront and manage their fears safely and controlled.

*Patient Empathy and Experiences:* Virtual reality can create immersive experiences that promote empathy and understanding among healthcare providers, caregivers, and the general public. By simulating the perspective of patients with specific conditions or disabilities, VR experiences can foster empathy, improve communication, and enhance the quality of care.

*Remote Consultations and Telemedicine:* Virtual reality can revolutionize remote healthcare consultations. It enables healthcare providers to conduct virtual visits, perform examinations, and provide guidance remotely. VR can bridge the distance gap, particularly in rural or underserved areas, improving access to healthcare services and reducing the need for travel.

While virtual reality offers numerous healthcare opportunities, some challenges include equipment cost, content development, user comfort, data privacy, and ethical considerations.

## Limitations of Virtual Reality

While virtual reality (VR) has shown excellent healthcare potential, certain limitations must be considered. Some of the limitations of virtual reality in healthcare include:

*Cost:* Virtual reality technology can be expensive, requiring specialized equipment such as head-mounted displays (HMDs) and motion-tracking devices. The high hardware and software development cost can hinder widespread adoption, particularly in resource-limited healthcare settings.

*Technical Challenges:* VR experiences must be highly immersive and realistic to be effective. Achieving high-quality graphics, smooth motion tracking, and low latency can be technically challenging. Developing and maintaining VR software and hardware requires expertise and ongoing support.

*User Discomfort:* Some individuals may experience discomfort or motion sickness when using VR devices, known as cybersickness or simulator sickness. This can include symptoms such as nausea, dizziness, and eye strain. User comfort is crucial; not all individuals may tolerate long VR experiences.

*Lack of Standardization:* The field of virtual reality is rapidly evolving, and there needs to be standardized protocols and guidelines for VR applications in healthcare. The absence of standards can hinder interoperability, data sharing, and comparability of results across different VR platforms and systems.

*Limited Evidence and Research:* Growing interest and initial evidence support VR's effectiveness in healthcare; more research is needed to establish its long-term benefits and outcomes. Larger-scale clinical studies and rigorous evaluation are necessary to validate VR

interventions' efficacy, safety, and cost-effectiveness in different healthcare contexts.

*Ethical Considerations:* Virtual reality raises ethical concerns about privacy, informed consent, and data security. Patient data collected during VR sessions must be handled carefully to ensure confidentiality and compliance with privacy regulations.

*Access and Usability:* VR technology may not be accessible or usable for all patient populations. Individuals with physical disabilities, visual impairments, or cognitive limitations may face challenges in engaging with VR systems effectively. Ensuring inclusivity and accessibility in VR healthcare applications is essential.

*Integration into Clinical Workflow:* Integrating VR into clinical workflows can be complex. Healthcare providers need training and support to incorporate VR technologies into their practice effectively. Compatibility with electronic health records (EHRs) and other healthcare systems is crucial for seamless integration.

*Content Development and Validation:* Developing high-quality VR content tailored to specific healthcare applications requires expertise and resources. Validating the effectiveness and safety of VR interventions through rigorous testing and validation processes is essential to ensure reliable and evidence-based outcomes.

Despite these limitations, ongoing advancements in virtual reality technology increased affordability, and growing evidence of its benefits suggests that VR has the potential to play a significant role in various aspects of healthcare in the future.

## I(b). Augmented Reality

### Introduction

Augmented Reality (AR) in healthcare refers to the application of augmented reality technology in various aspects of healthcare delivery, including medical education, clinical practice, patient care, and healthcare management. AR blends virtual elements with the real-world environment, providing an enhanced and interactive experience for healthcare professionals, patients, and caregivers.

In healthcare, augmented reality overlaps digital information, such as images, graphics, or text, onto the real-world view. This information can be displayed on devices like smartphones, tablets, smart glasses, or headsets, allowing users to visualize and interact with virtual objects or data within their physical surroundings.

### Advantages and Key Features of Augmented Reality

*Medical Education and Training:* AR provides an immersive and interactive learning experience for medical students and healthcare professionals. It allows them to visualize and manipulate virtual anatomical models, perform virtual surgeries, and practice complex medical procedures in a simulated environment. AR-based training enhances the spatial understanding, improves knowledge retention, and promotes hands-on learning.

*Surgical Planning and Guidance:* Augmented reality can assist surgeons in pre-operative planning by overlaying patient-specific anatomical data in the real-time surgical field. Surgeons can visualize and navigate the patient's anatomy, accurately plan incisions, identify critical structures, and precisely position surgical instruments. AR can also provide real-time guidance during surgeries, directly displaying

relevant information and visual cues within the surgeon's field of view.

*Medical Visualization and Imaging:* AR can enhance the interpretation and visualization of medical imaging data, such as MRI or CT scans. By overlaying these images onto the patient's body, AR enables physicians to visualize the internal structures in real-time during procedures, making locating tumours, blood vessels, or other targets easier. This technology can improve accuracy, reduce risks, and enhance surgical outcomes.

*Rehabilitation and Physical Therapy:* Augmented reality is used in rehabilitation and physical therapy to improve patient engagement and motivation. AR systems can provide real-time feedback, guide patients through exercises, and track their progress. By superimposing virtual objects or targets onto the patient's environment, AR-based therapy encourages movement, balance, and coordination, enhancing the effectiveness of rehabilitation programs.

*Remote Consultations and Telemedicine:* AR technology enables remote healthcare consultations by overlaying a healthcare professional's guidance or expertise onto the patient's environment. Using AR-enabled devices, physicians can guide patients or remote caregivers in performing medical procedures, administering medications, or managing chronic conditions. This technology facilitates remote diagnosis, treatment monitoring and reduces the need for in-person visits.

*Medical Simulation and Patient Education:* AR-based medical simulations allow patients to understand better their medical conditions, treatment options, and potential outcomes. By visualizing the impact of different interventions on their bodies or using interactive educational tools, patients can make informed decisions and actively participate in their healthcare journey.

*Mental Health and Rehabilitation:* Augmented reality is also being explored for various applications in the mental health field. It can create immersive and controlled environments to gradually expose individuals to anxiety-provoking situations, such as phobia treatment or exposure therapy. AR can also be used in cognitive rehabilitation for patients with neurodegenerative disorders or brain injuries, providing interactive exercises and cognitive challenges.

Augmented reality can enhance medical procedures, improve patient outcomes, and transform the healthcare experience by providing real-time information, guidance, and interactive visualization. However, further research, validation, and integration with existing healthcare systems are needed for broader adoption and implementation.

## Limitations of Augmented Reality in Health Care

While augmented reality (AR) can transform healthcare, several limitations and challenges must be considered. Some of the limitations of augmented reality in healthcare include:

*Technical Challenges:* Augmented reality relies on complex technological infrastructure, including hardware devices, software applications, and data integration. Technical challenges such as hardware limitations, device calibration, tracking accuracy, and latency can affect AR systems' performance and user experience. The technology must be reliable, robust, and seamlessly integrated with existing healthcare systems.

*Cost and Accessibility:* AR devices, such as smart glasses or headsets, can prevent widespread adoption in healthcare settings. The initial investment, maintenance, and upgrade costs may limit access to AR technology, particularly for smaller healthcare facilities or resource-limited settings. Additionally, there may be disparities in access to AR technology across different regions or populations.

*User Acceptance and Comfort:* Augmented reality experiences can be immersive and require users to wear devices on their heads or faces for an extended period. User acceptance and comfort are crucial for successful implementation. Some individuals may experience discomfort, fatigue, or motion sickness when using AR devices, which can limit their acceptance and usage. Addressing ergonomic design, user interface intuitiveness, and minimizing adverse effects is essential for user acceptance.

*Data Privacy and Security:* AR applications in healthcare often involve the use and processing of sensitive patient data, including medical images, patient records, or real-time physiological data. Data privacy and security are essential to protect patient confidentiality and comply with regulations. Robust data encryption, secure transmission, and adherence to privacy standards are necessary for maintaining patient trust.

*Limited Evidence and Validation:* While there is a growing interest and potential in using AR in healthcare, more research is needed to establish its effectiveness, safety, and clinical outcomes. Large-scale studies, clinical trials, and validation processes are required to provide evidence of the impact of AR on patient outcomes, workflow efficiency, and cost-effectiveness.

*Integration into Clinical Workflow:* Augmented reality systems must be seamlessly integrated into existing clinical workflows and healthcare practices to be effective. Integration challenges may arise from compatibility issues with electronic health records (EHRs), interoperability with other healthcare systems, and the need for staff training and support. AR solutions should fit within the existing healthcare infrastructure without disrupting the workflow or creating additional burdens.

*Regulatory and Legal Considerations:* Using augmented reality in healthcare raises regulatory and legal considerations. AR applications

must comply with relevant regulations, standards, and certifications to ensure patient safety, accuracy, and adherence to clinical guidelines. Additionally, liability issues and responsibility for interpreting and using AR-generated information must be clarified.

Despite these limitations, ongoing advancements in technology, decreasing costs, and increasing awareness of the potential benefits of AR in healthcare suggest that these challenges can be addressed over time. Continued research, development, and collaboration among stakeholders are necessary to overcome the limitations and maximize the potential of augmented reality in healthcare.

# J. Blockchain in Healthcare

## Introduction

Blockchain is a decentralized and distributed digital ledger technology that securely records and verifies transactions across multiple computers or nodes. In healthcare, blockchain technology can potentially transform various aspects of the healthcare industry, including data management, interoperability, security, and patient-cantered care.

In healthcare, blockchain can create a transparent and immutable record of transactions, data exchanges, and activities.

## Advantages and Key Features of Blockchain in Healthcare

*Health Data Exchange and Interoperability:* Blockchain enables secure and efficient health data sharing among healthcare providers, researchers, and patients. It allows the creation of a unified, decentralized, and tamper-proof health record that authorized parties can access. Blockchain can help address the interoperability challenges by providing a standardized and secure method for data exchange.

*Data Security and Privacy:* Blockchain offers enhanced security and privacy for sensitive healthcare data. It uses cryptographic techniques to secure data integrity, authenticate users, and prevent unauthorized access or tampering. With blockchain, patients have more control over their data and can grant access to specific healthcare providers or researchers while maintaining their privacy.

*Clinical Trials and Research:* Blockchain technology can streamline and improve the integrity of clinical trials and research studies. It provides a transparent and auditable trail of data related to study

protocols, informed consent, data collection, and analysis. Blockchain can enhance the accuracy and reliability of research data, facilitate participant recruitment, and ensure ethical compliance.

*Supply Chain Management:* Blockchain can be applied to track and trace the supply chain of pharmaceuticals, medical devices, and healthcare products. By recording every transaction and movement of products on the blockchain, stakeholders can ensure the supply chain's authenticity, safety, and integrity. This can help prevent counterfeiting, improve quality control, and streamline logistics.

*Health Insurance and Claims Processing:* Blockchain can simplify health insurance processes, including claims management, eligibility verification, and payment settlements. By leveraging intelligent contracts on the blockchain, insurance transactions can be automated, reducing administrative costs, fraud, and errors. Blockchain can also enable real-time insurance coverage verification and simplify the reimbursement process.

*Identity Management:* Blockchain offers a decentralized and secure solution for identity management in healthcare. It can help establish a unique digital identity for patients, ensuring the accuracy and privacy of their personal information. Blockchain-based identity management systems can streamline patient registration, authentication, and access to healthcare services.

While blockchain technology has significant potential, it also faces some challenges in healthcare, including scalability, regulatory considerations, standardization, and adoption barriers. Overcoming these challenges and addressing the technical and operational requirements are crucial for blockchain's widespread implementation and integration in healthcare.

## Limitations of Blockchain in Healthcare

While blockchain technology holds promise for healthcare, several limitations and challenges must be considered. Some of the limitations of blockchain in healthcare include the following:

*Scalability:* Blockchain technology faces scalability challenges, particularly in public or permissionless blockchain networks. The decentralized nature of blockchain requires all nodes to store and validate every transaction, which can lead to performance issues and slower transaction processing times. As healthcare data volumes grow, scalability becomes crucial for blockchain implementation.

*Data Privacy and Confidentiality:* While blockchain offers enhanced security, the transparency and immutability of the technology may present challenges regarding data privacy and confidentiality. Healthcare data often contains sensitive and personally identifiable information, and ensuring privacy while maintaining the benefits of transparency is a complex task. Striking the right balance between data security and privacy is essential for blockchain adoption in healthcare.

*Regulatory and Legal Considerations:* Healthcare is subject to numerous regulatory requirements, such as data protection regulations (e.g., GDPR), patient consent, and health information exchange standards. Blockchain implementation must comply with these regulations, and adapting existing legal frameworks to accommodate blockchain can be challenging. Additionally, clarifying liability and responsibility for data breaches or inaccuracies within a decentralized system is a legal consideration.

*Interoperability and Standardization:* Achieving interoperability between different blockchain platforms and existing healthcare systems is a significant challenge. Healthcare organizations use various systems and standards for data exchange, and integrating

blockchain into these diverse environments requires interoperability standards and protocols. Lack of standardization across blockchain implementations may hinder seamless data sharing and collaboration.

*Governance and Consensus Mechanisms:* Blockchain networks require consensus mechanisms to validate and verify transactions. Selecting an appropriate consensus mechanism that aligns with healthcare needs, balances security and performance, and ensures the participation of relevant stakeholders can be complex. Establishing governance models for decision-making, updates, and maintenance of the blockchain network is also crucial but can be challenging in decentralized environments.

*Adoption and Integration:* Adopting blockchain technology in healthcare requires significant investments in infrastructure, training, and cultural changes. Healthcare organizations and providers may face challenges in understanding and embracing blockchain, integrating it with existing systems, and ensuring user acceptance. Overcoming resistance to change and fostering a collaborative environment for blockchain implementation are essential considerations.

*Energy Consumption:* Blockchain networks consume significant energy, especially those that use proof-of-work consensus mechanisms. This energy consumption can be a concern, both from an environmental perspective and in terms of cost-effectiveness for healthcare organizations. Exploring alternative consensus mechanisms that are more energy-efficient is an area of ongoing research and development.

Addressing these limitations and challenges requires collaborative efforts among healthcare stakeholders, technology providers, policymakers, and regulatory bodies. Research, development, and pilot projects are crucial to test the feasibility,

## Digital Health Care Initiatives

scalability, and practicality of blockchain in healthcare and to identify solutions to overcome these limitations.

# Conclusion for Digital Healthcare Initiatives

Digital healthcare initiatives have significantly improved healthcare delivery, patient care, and population health management. Telemedicine has expanded access to healthcare services, overcoming geographic barriers and improving patient convenience. Electronic health records have enhanced patient information storage, retrieval, and sharing, improving care coordination and clinical decision-making. Mobile health applications have empowered individuals to actively engage in their health and monitor their well-being. Artificial intelligence has shown promise in assisting with diagnostics, treatment planning, and predicting patient outcomes. Remote patient monitoring has enabled continuous monitoring of patient's health status, promoting early intervention and reducing hospitalizations. Health information exchange has facilitated the secure and seamless exchange of patient data across healthcare providers, improving care continuity. Precision medicine has personalized treatment approaches based on individual characteristics and genetic information, leading to more targeted and effective interventions. Data analytics and population health management have provided insights into population health trends, allowing for proactive interventions and resource allocation.

However, despite the numerous benefits, these digital healthcare initiatives also face limitations. These include concerns regarding the privacy and security of patient data, challenges in data quality and standardization, resource constraints for implementation, the need for skilled personnel, interoperability issues, ethical considerations, and the potential for bias in data analysis. Overcoming these limitations requires concerted efforts from healthcare organizations, policymakers, technology vendors, and other stakeholders.

In conclusion, digital healthcare initiatives have the potential to transform healthcare delivery, improve patient outcomes, and enhance population health management. While challenges exist, continued advancements in technology, data governance practices, and regulatory frameworks will help address these limitations and unlock the full potential of digital health in improving healthcare access, quality, and outcomes for individuals and populations.

www.ingramcontent.com/pod-product-compliance
Lightning Source LLC
Chambersburg PA
CBHW070429180526
45158CB00017B/941